ONE-OF-A-KIND

Adult Coloring Pages: DRAWN to Chill & Thrill

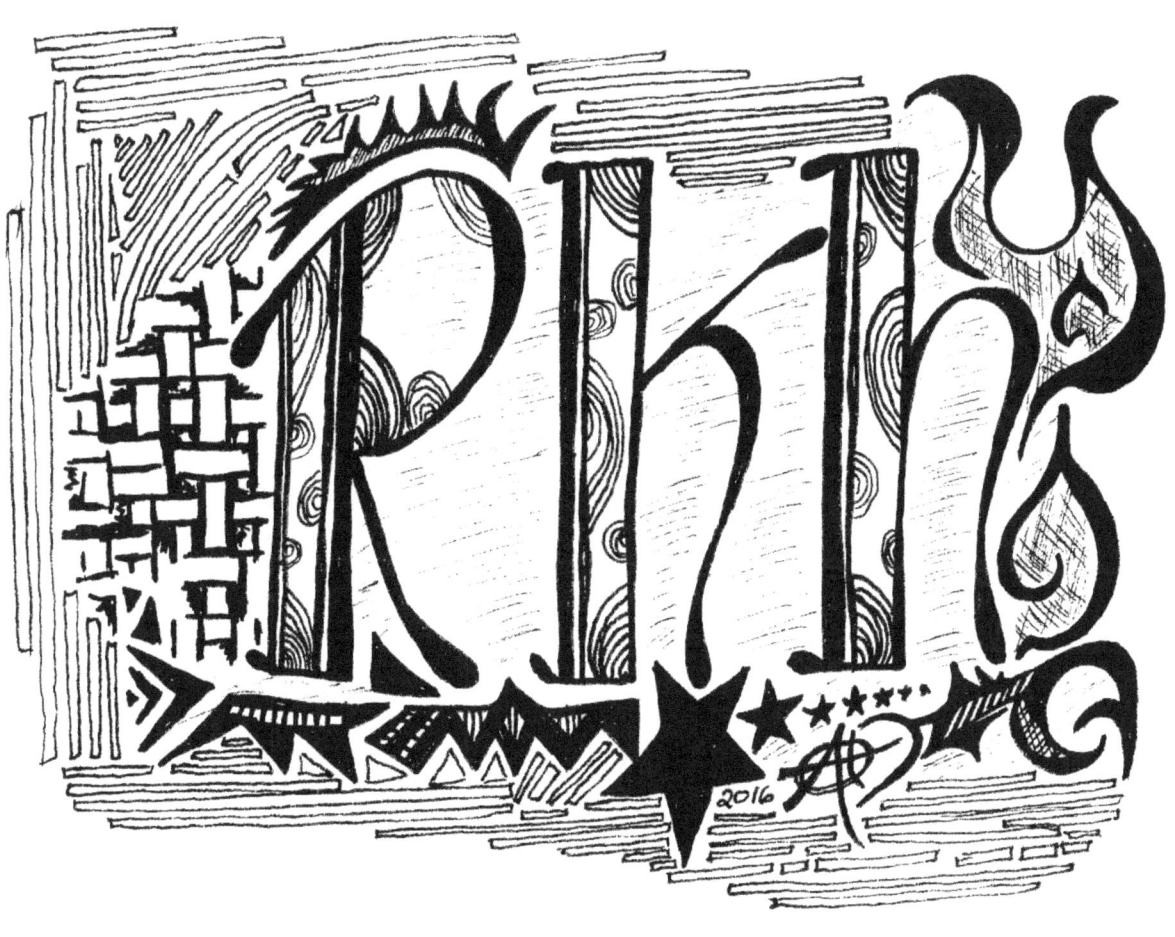

Ange'lique Michel'e Marley

DEDICATION

This is for the one who has always been there to pick up the pieces, the one who had my back whether I was right or wrong

and my ever supportive and understanding family.

Thank you.

Copyright © 2016 Ange'lique Michel'e Marley

All rights reserved.

ISBN: 1535463767

ISBN-13: 978-1535463768

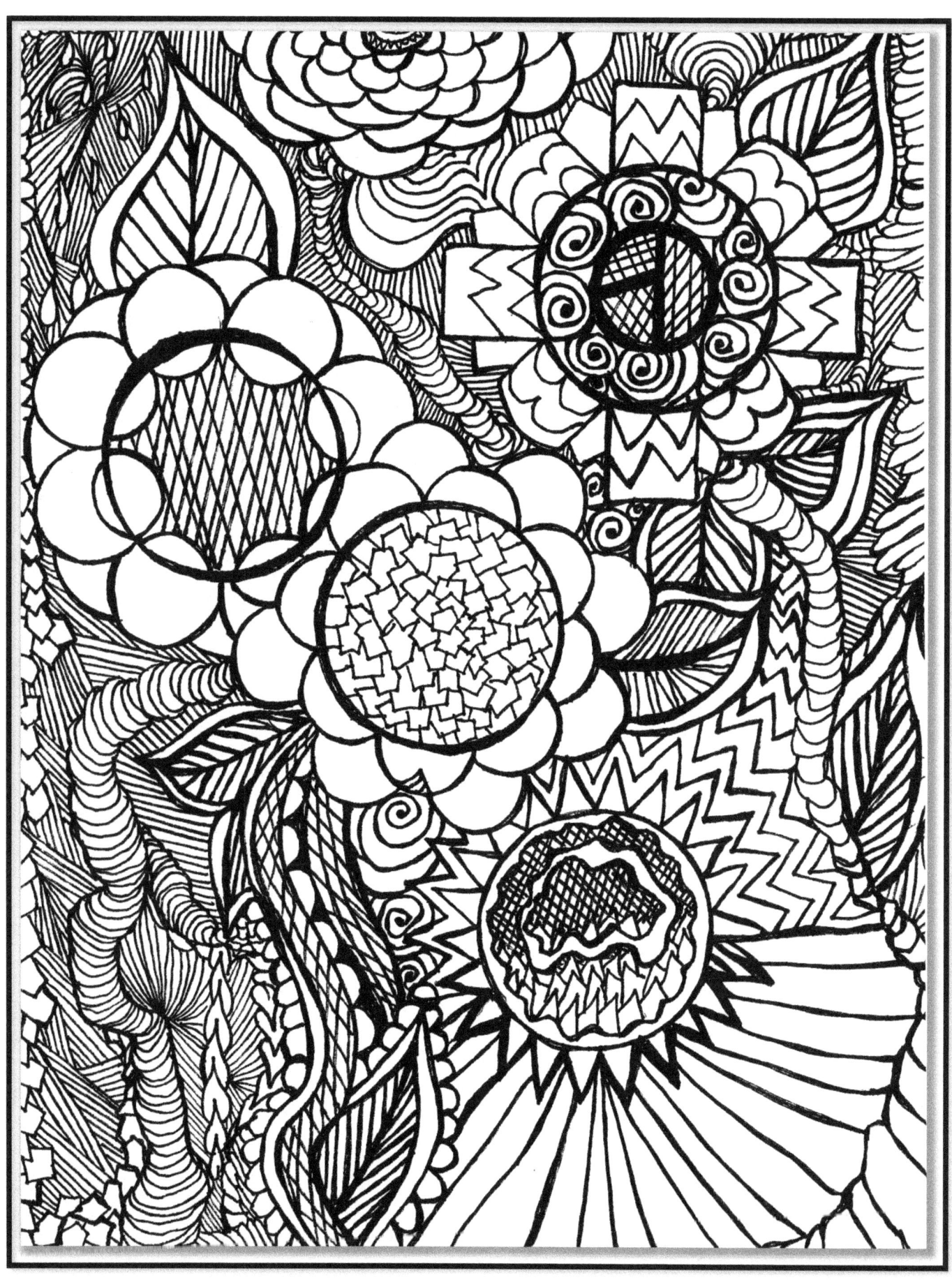

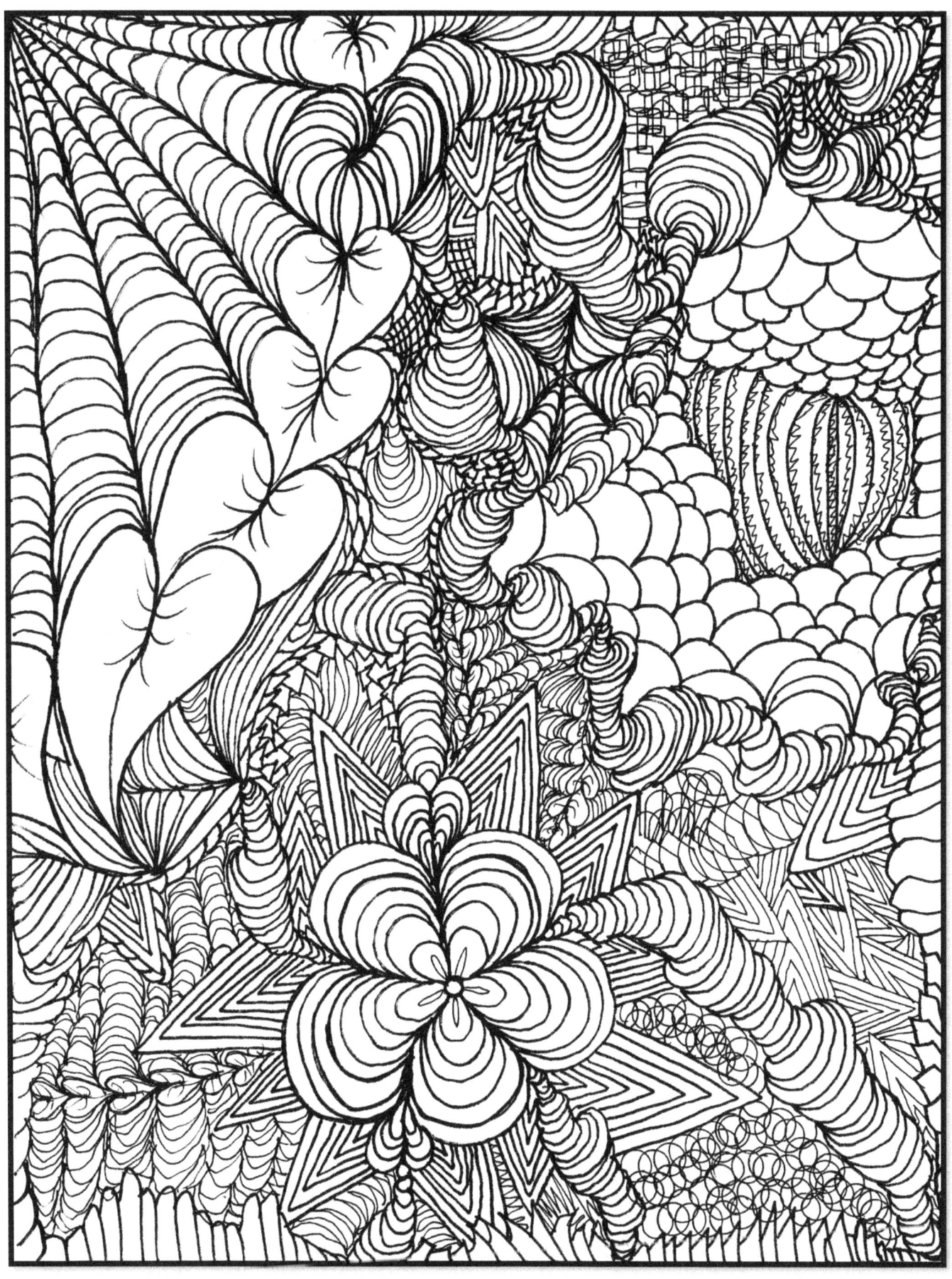

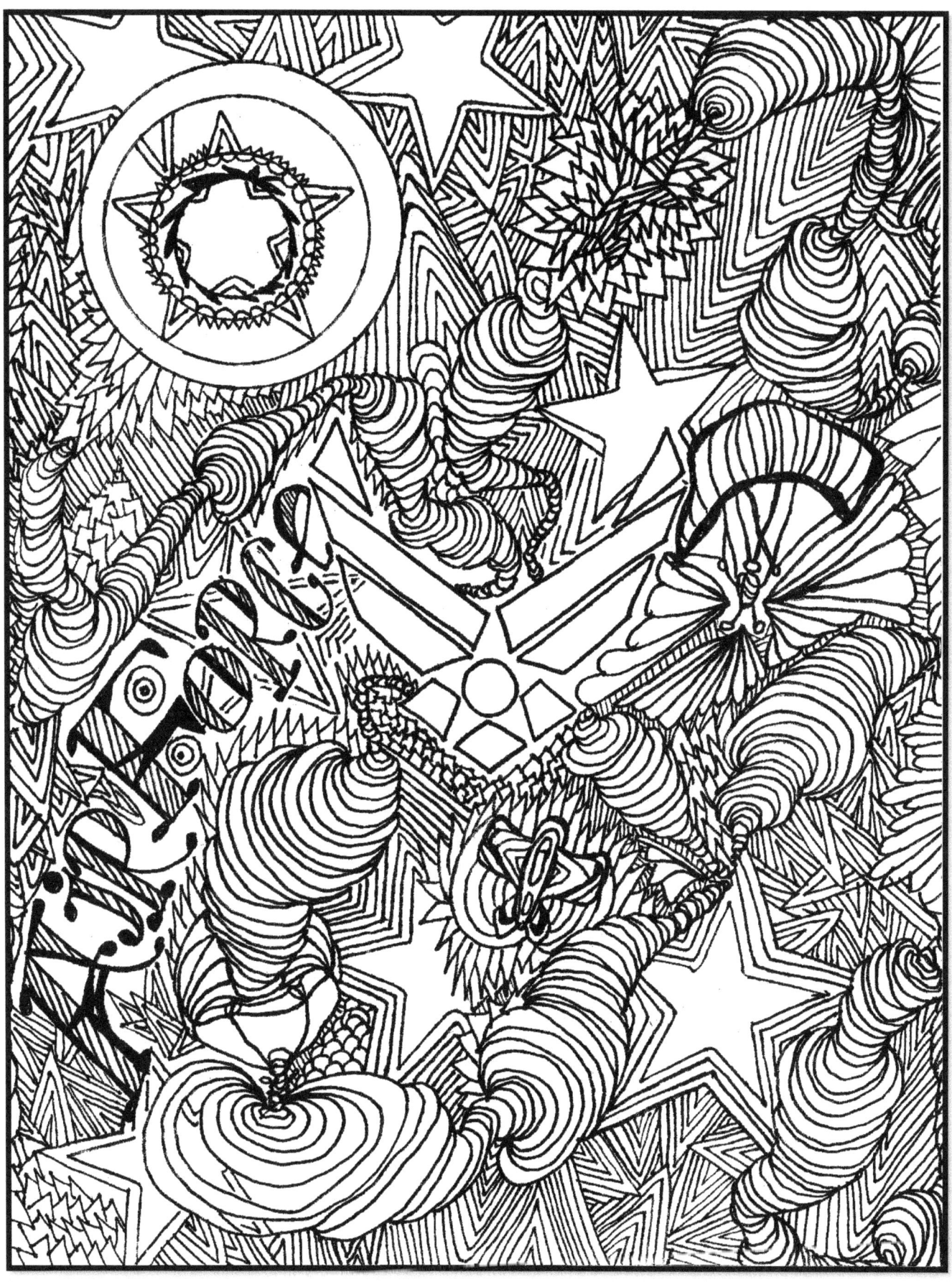

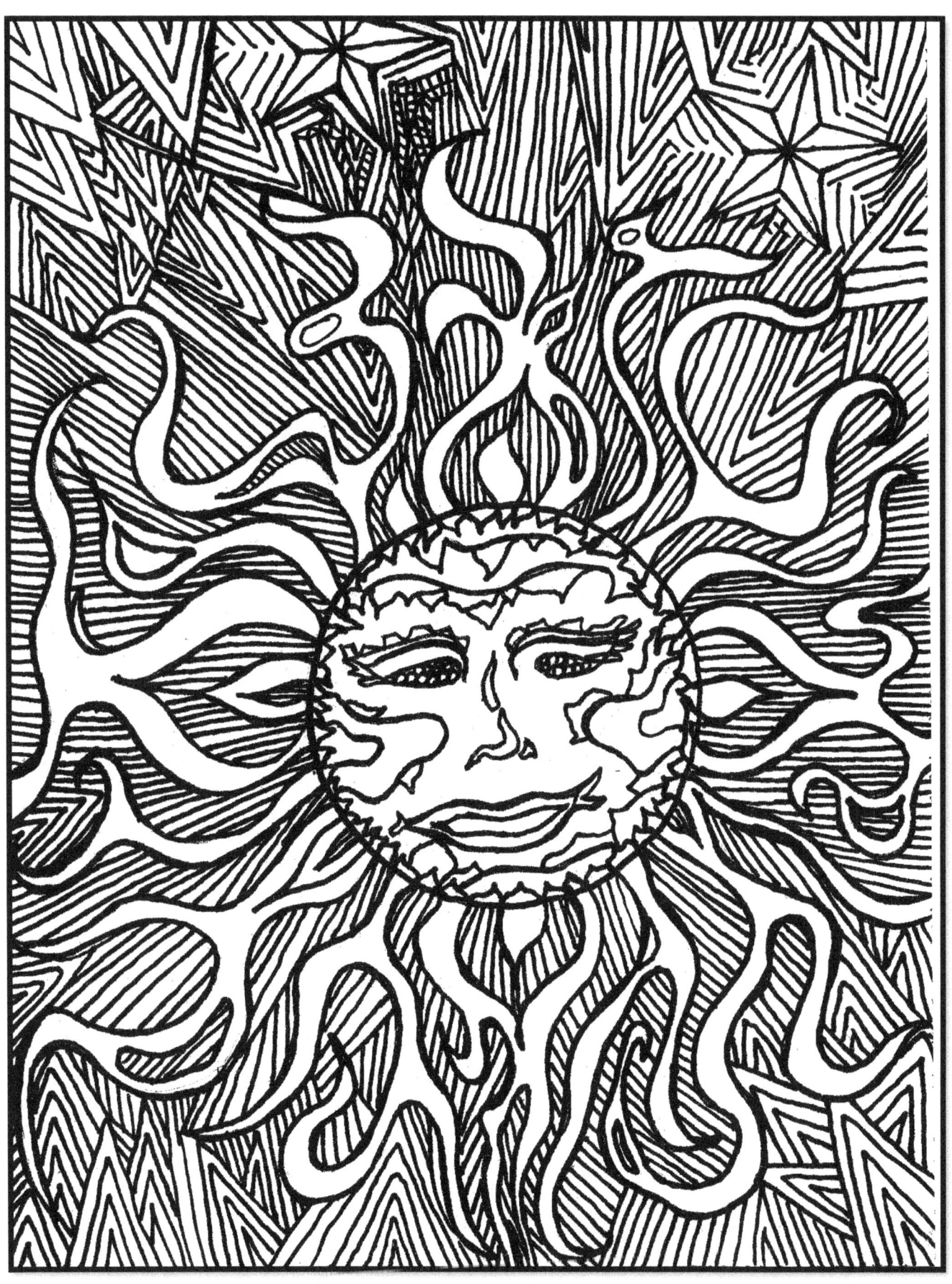

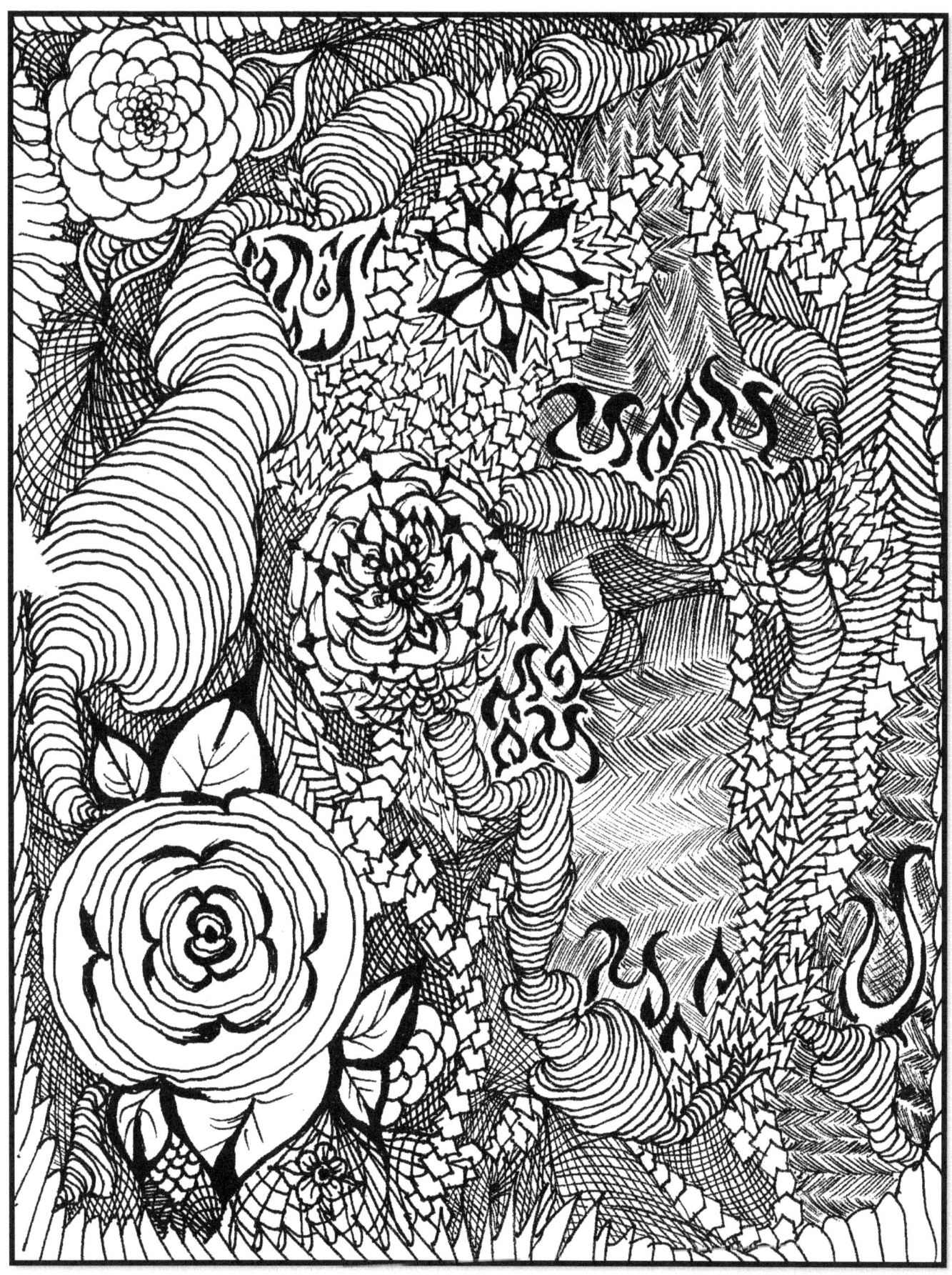

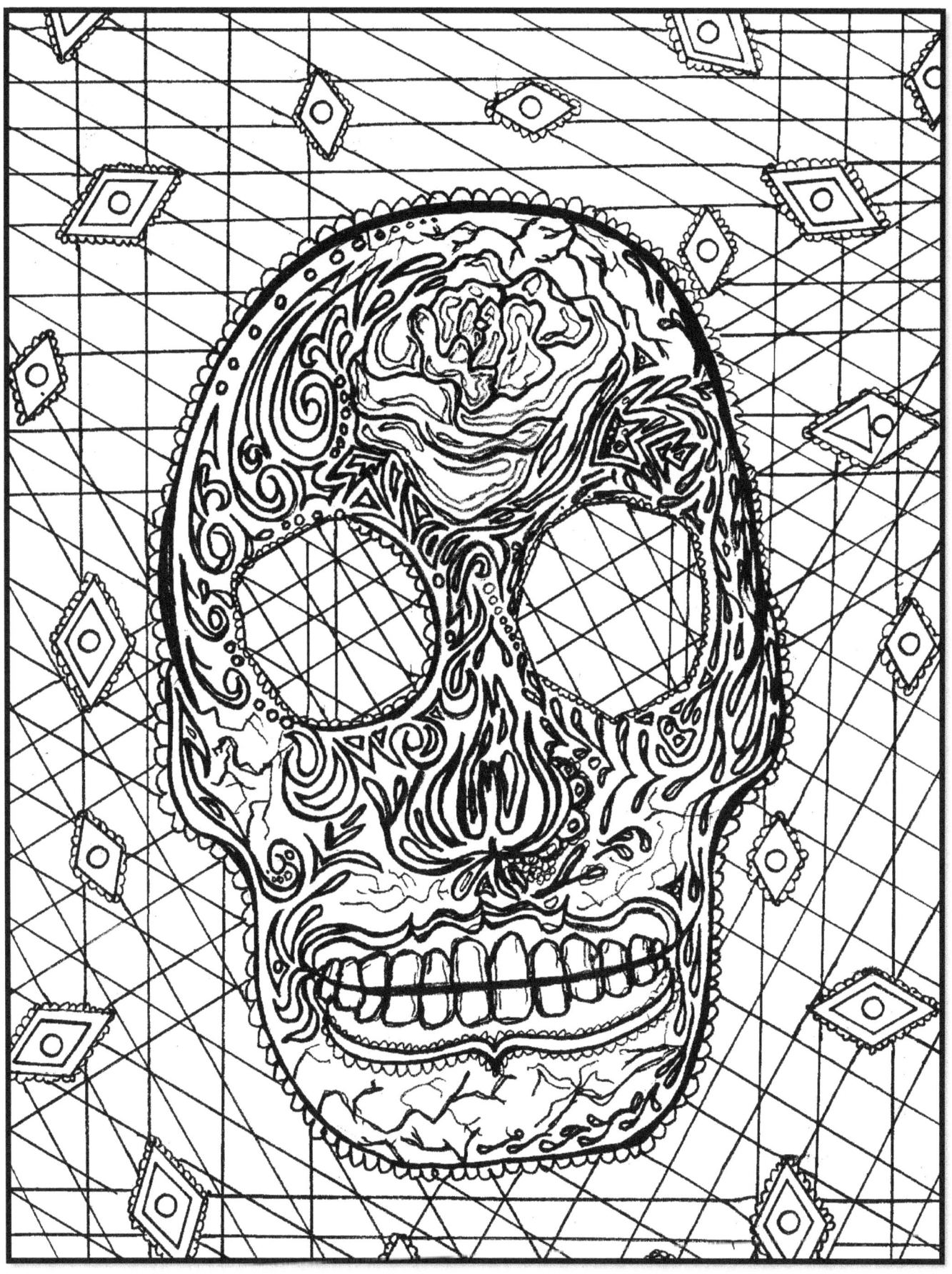

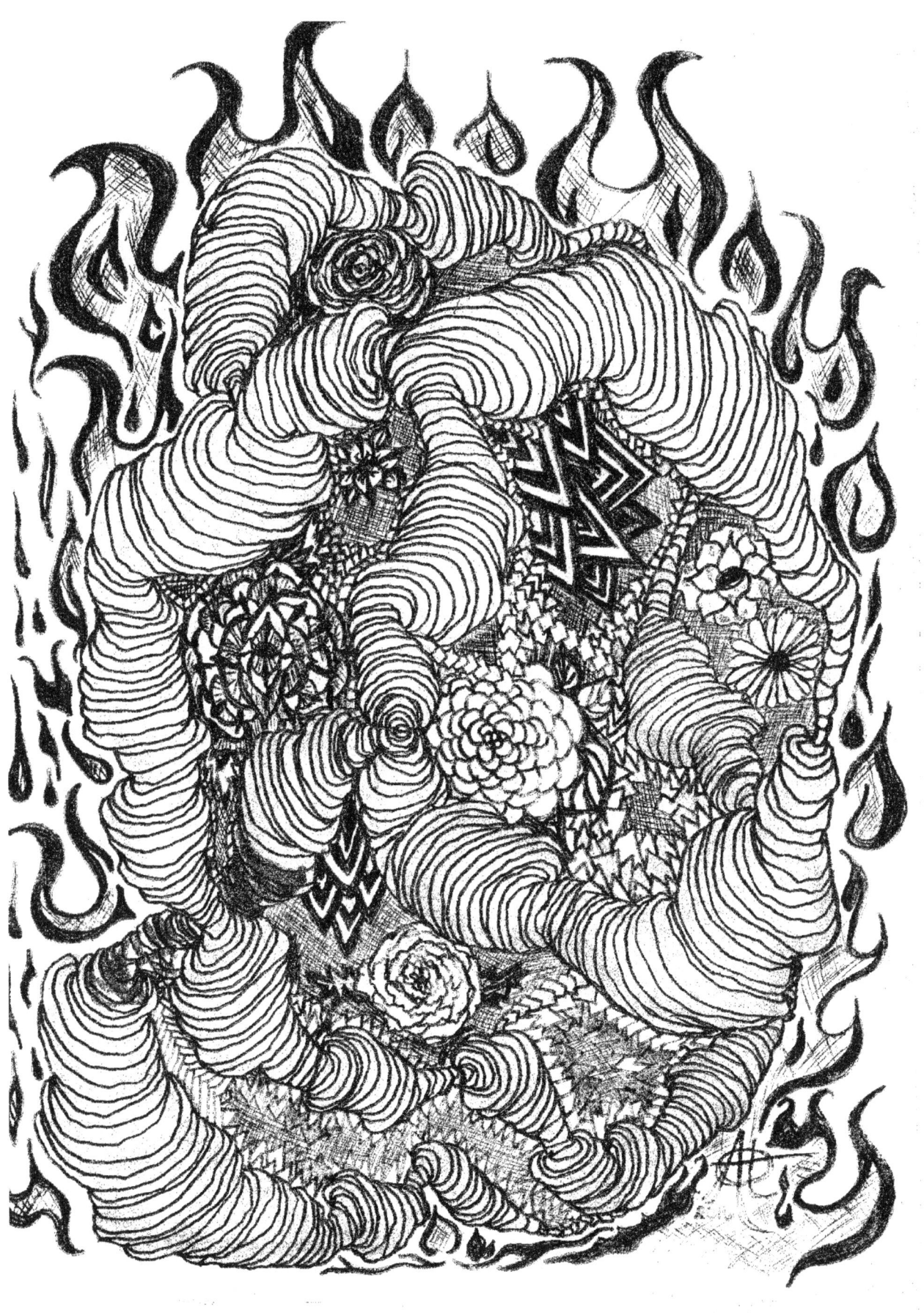

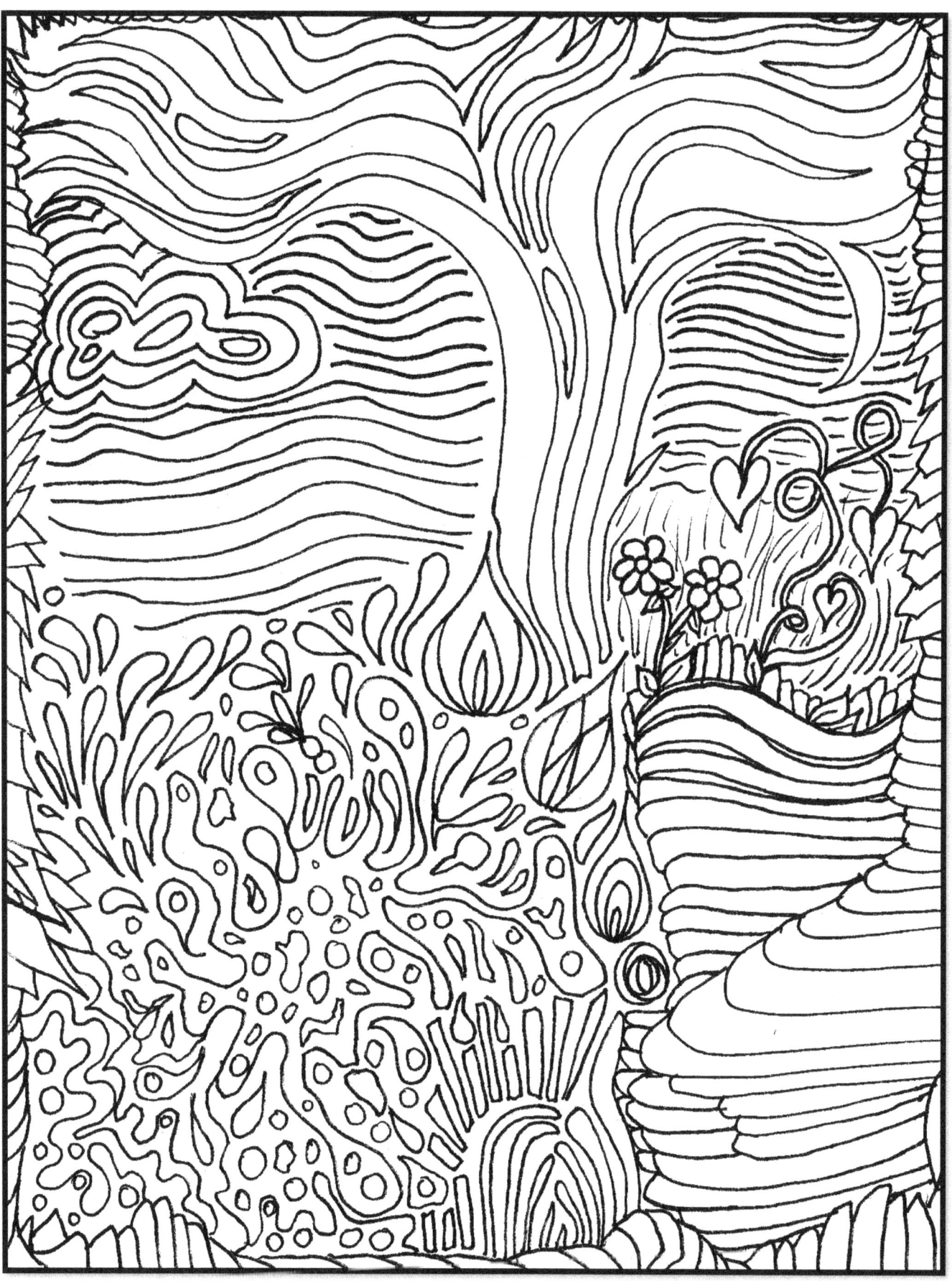

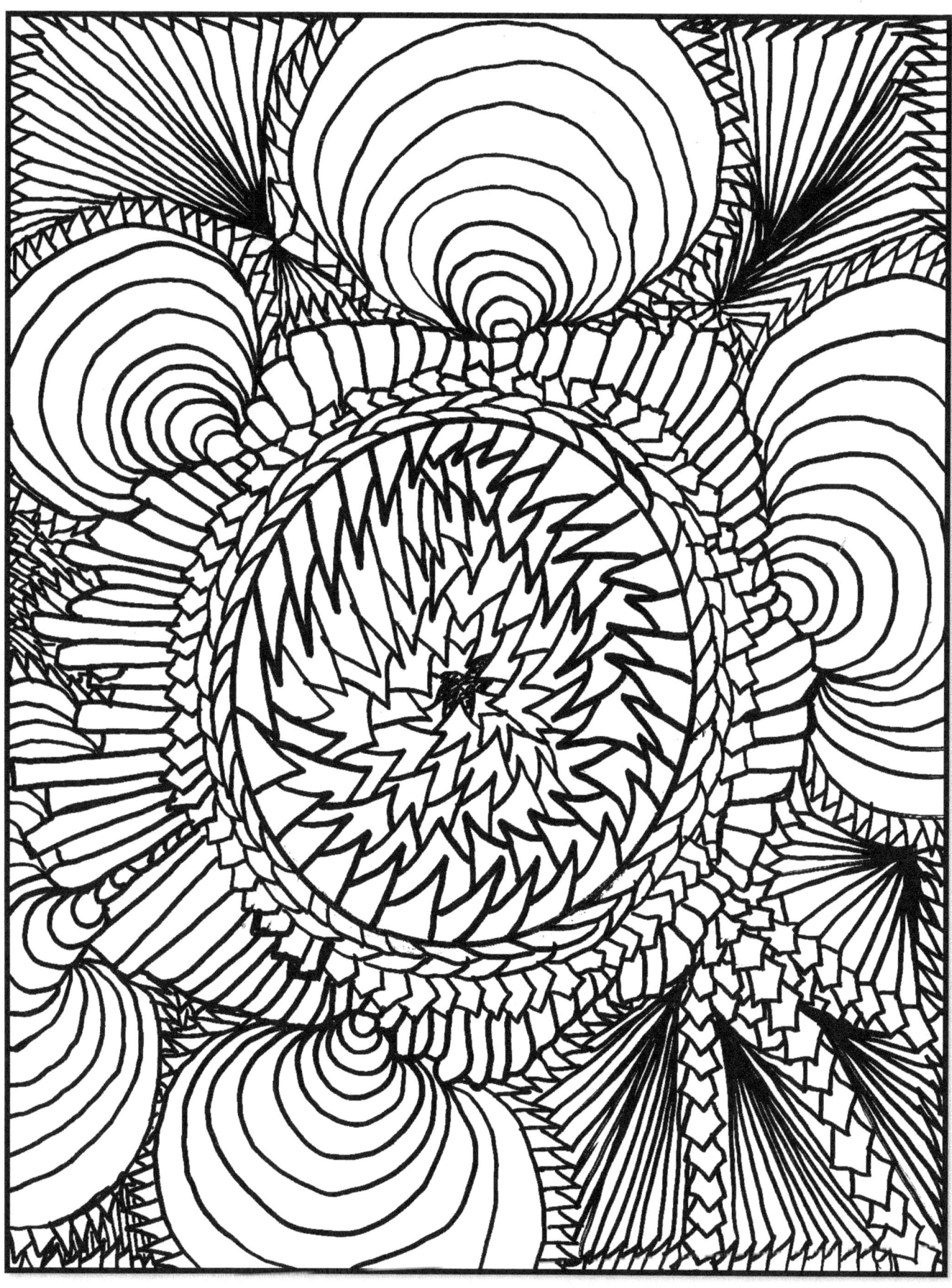

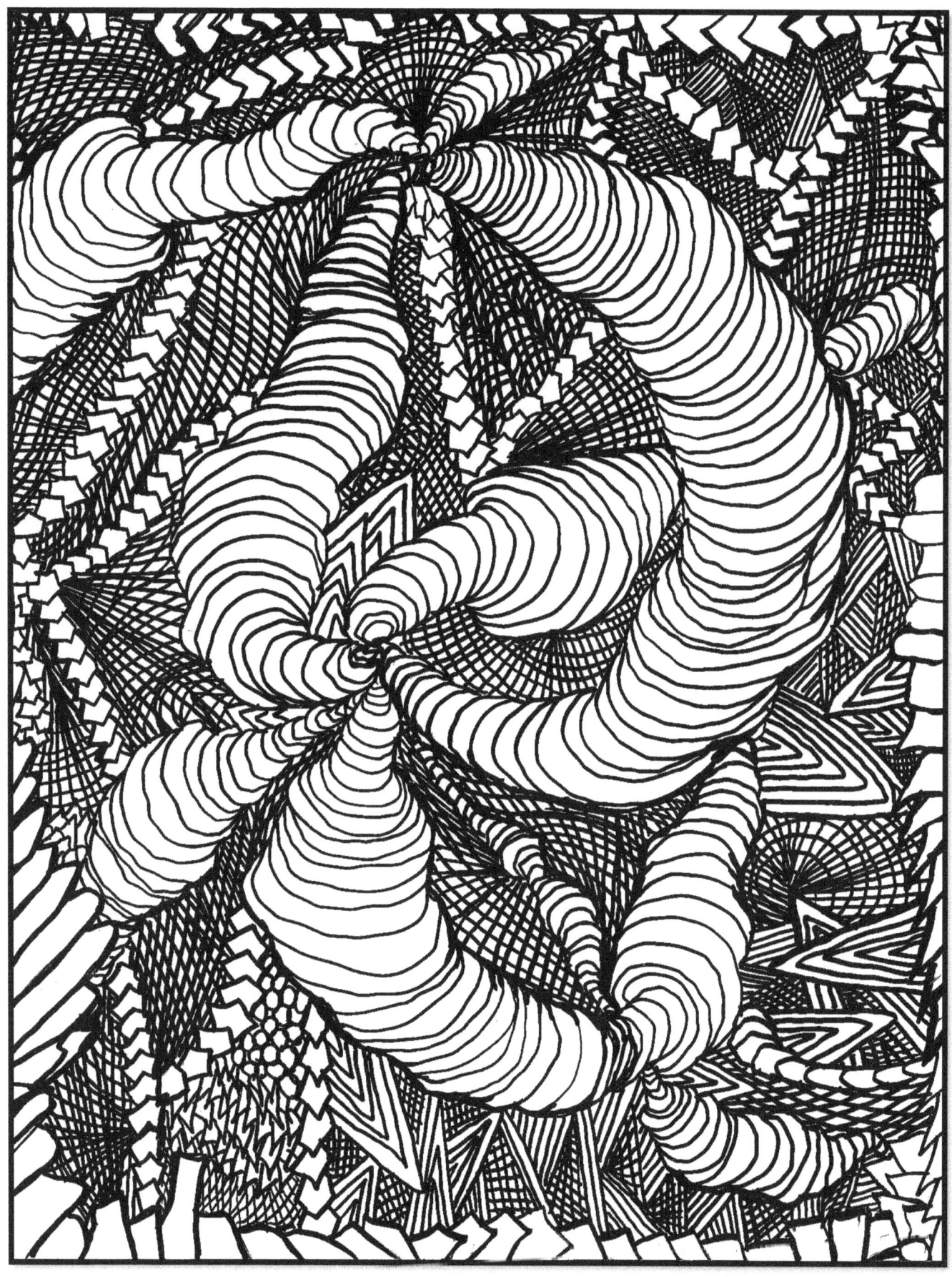

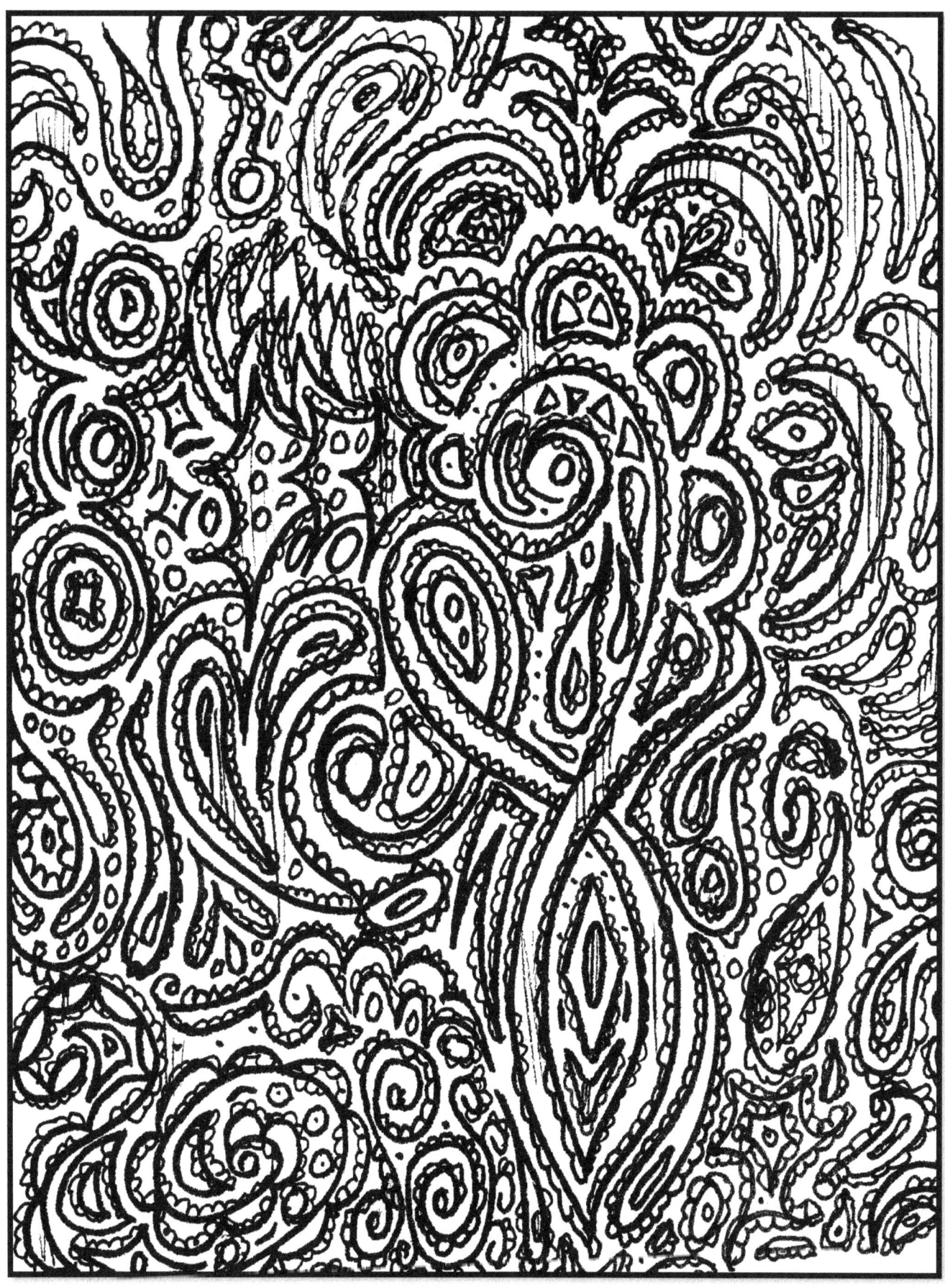

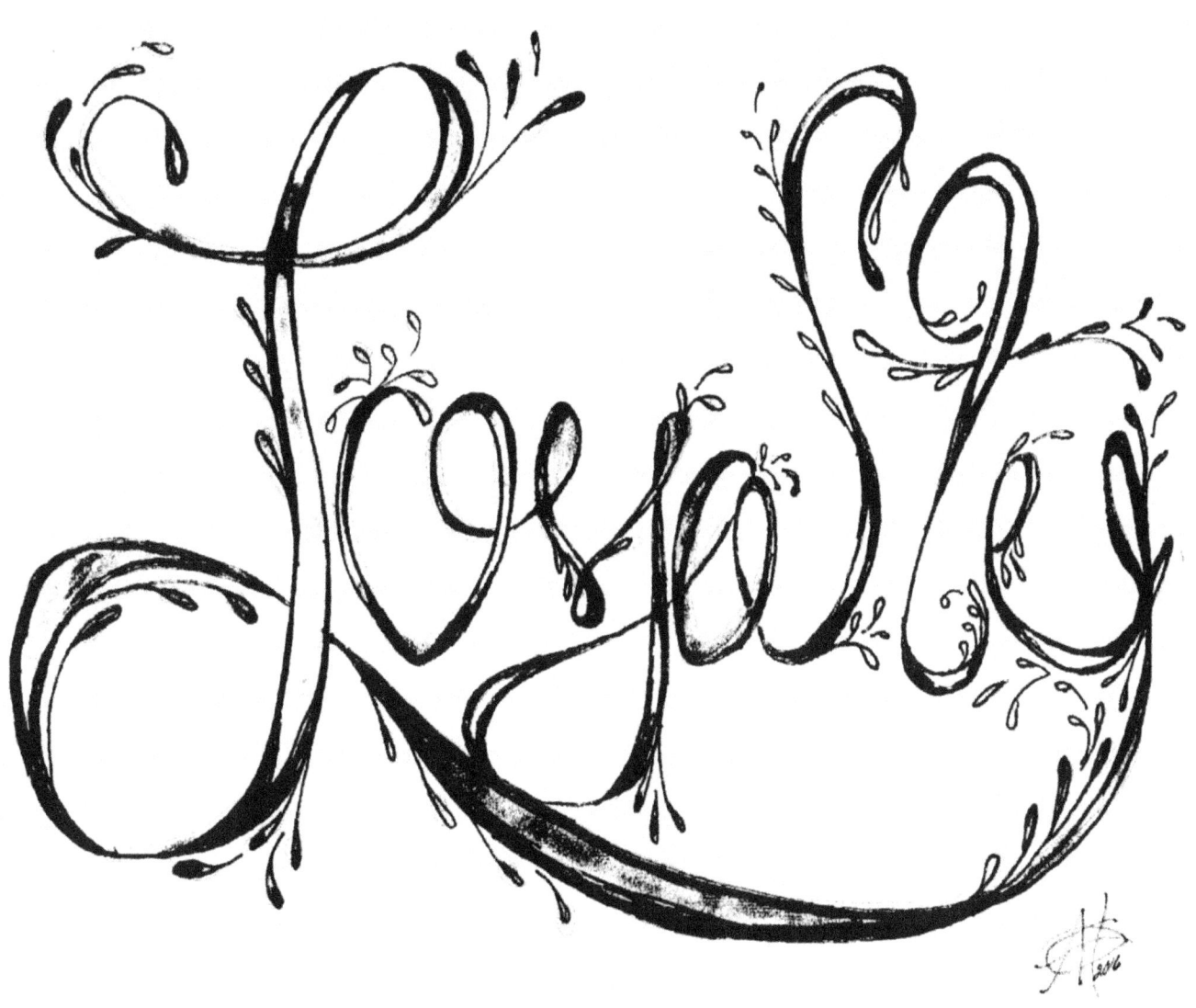

www.ingramcontent.com/pod-product-compliance
Lightning Source LLC
Chambersburg PA
CBHW080533190526
45169CB00008B/3148